RONNIE BARKER'S

Book of Bathing Beauties

HODDER & STOUGHTON

London Sydney ♔ Auckland Toronto

"Beauty is truth, truth beauty" *John Keats*
"Beauty is in the eye of the beholder" *Proverb*
"Beauty is only skin deep" *Max Factor*
"Oh what a beauty" *Anon*

I dedicate the following pages to my dear wife—
without whom all this
would have been possible. R.B.

I would like to acknowledge the enormous contribution
made by those many kind people who loaned photographs and other
material for the illustrations in this book.

Their names alone would almost fill the pages;
and it was therefore decided to include instead a group photograph
of them all, taken on the steps of the publisher's offices.

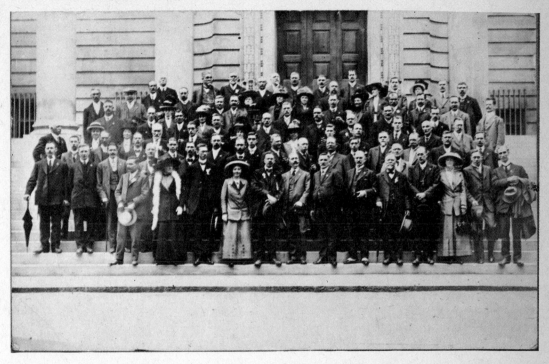

To anyone who is not in the photograph who should be, may I offer
my sincere apologies; and to any passer-by who *is* there who shouldn't be,
all I can say is, it's a damned rude thing to do. *R.B.*

Foreword

As, almost without exception, forewords to books are tedious to the extreme, I intend to skip this one altogether, and move immediately on to the Introduction.

Introduction

"Why Bathing Beauties?" The age-old question is bound to be asked by many who, stumbling across a bookshop for the first time, cautiously enter its portals, wondering what sort of things are for sale within (indeed it may also be asked by people who read four novels a week and still manage to find time to have children).

In reply to that age-old question comes an even older answer—"Why not?" This work is not an informed treatise on anything in particular. It is a picture book, devoted to the wonders and eccentricities of the female form, taking a light-hearted and at times one might even say lighted-headed look at Bathing in all its various forms and fantasies. It is not confined to any one class of society; the servant girl, the duchess, the nursemaid, all are included; and girls in many other positions as well.

Of course, the Bathing Beauty, as such, is not real. The models themselves are a curious breed, they do odd things, keep strange hours, wear wonderful, impractical costumes; have eccentric habits (see subsection entitled "Dressing In The Wrong Order"). However, the realists among you will be glad to know that there has been included a short Appendix (No. III) consisting entirely of photographs of real people bathing.

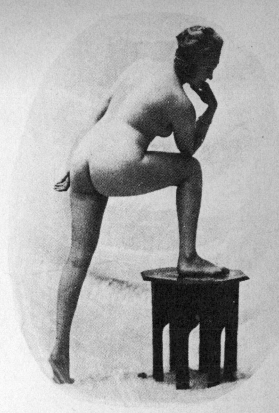

There is nothing new in this book; nothing that a man couldn't see by taking a good look at his wife; but the subject is so delightfully presented by the photographer and artist that I think no one can fail to be enchanted; and I'm sure that the girls on the following pages will spring to life, re-creating those golden days in the early-morning summer of our youth.

If, however, the girls fail to spring to life, and the reader fails to be enchanted etc., I very much regret that NO MONEY WILL BE REFUNDED.

Ronnie Barker, Bayswater, W.

Contents

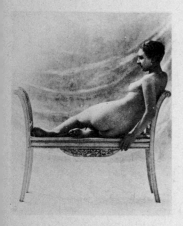

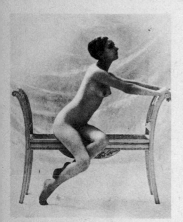

Shall we plunge in?

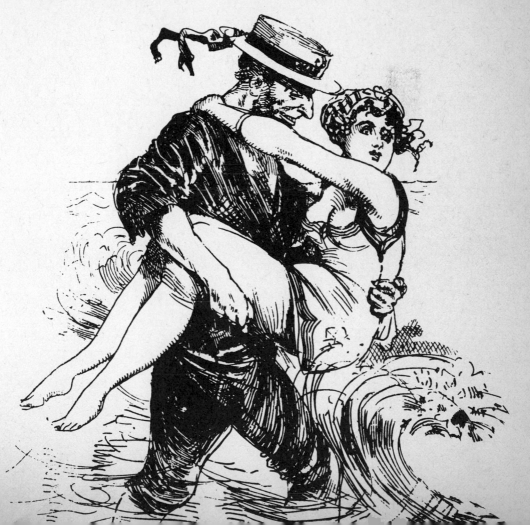

SECTION ONE
OUTDOOR BATHING

"The sunlight on the water, and someone else's daughter, oh, oh, oh, to be by the sea!"

So went the old song, or *would* have done if someone had taken the trouble to write it. The Bathing Beauty's natural habitat is, of course, the silver sand: and splashing about in the briny . . .

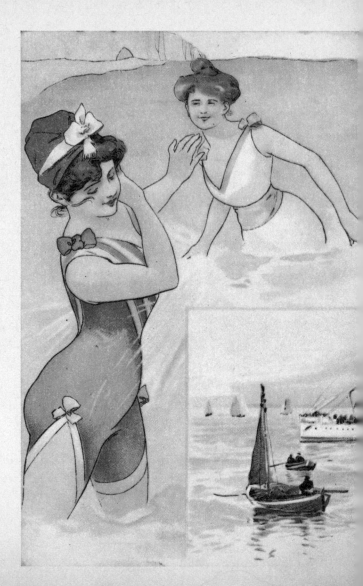

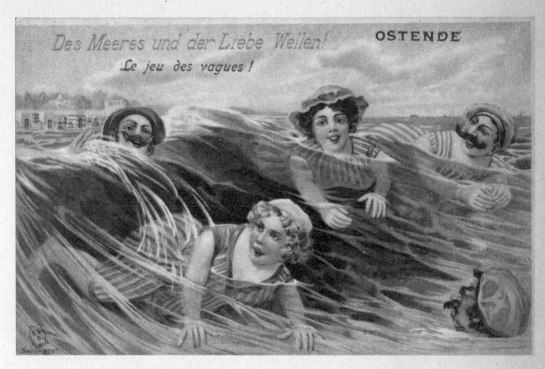

Des Meeres und der Liebe Wellen!
Le jeu des vagues!

OSTENDE

. . . has always been popular,
mainly due to the fact that "mixed" bathing is
considered socially in order, when performed
out-of-doors; indoors, however, it is very much
looked down on by the staff (usually the butler,
through a hole bored in the bathroom ceiling).

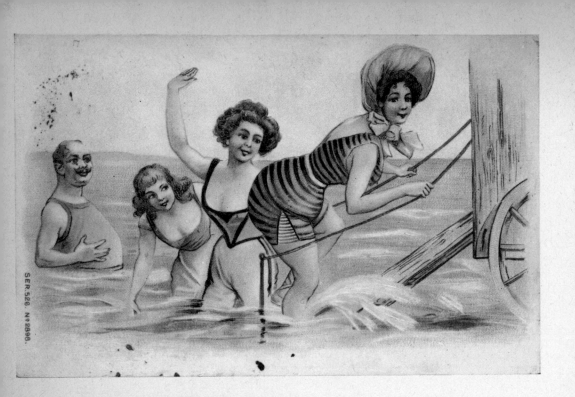

The picture-postcards which are posted in their thousands reflect the air of boisterous gaiety which seems to prevail everywhere—a slap-happy, "this-place-will-take-some-beating" attitude which usually develops into a romp, only turning nasty when one of the dainty protagonists manages to get hold of a paddle.

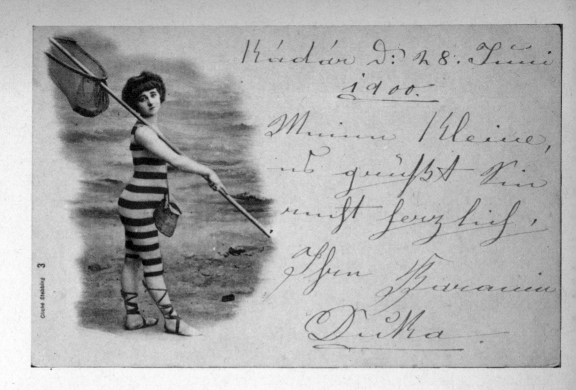

Not only the water itself, but the sea-shore and
rock-pools offer untold delights to a girl such as
the one we see here, looking like a stick of rock
that someone has licked into shape.

Below, we see a selection of the things she caught
for her tea.

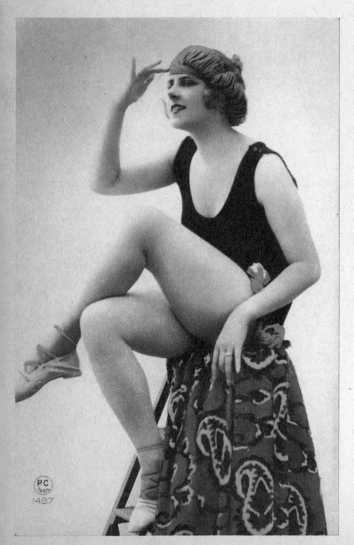

This girl is a typical Bathing Beauty; that is to say, she is not all that she seems to be.
A. She is *not* Scots, in spite of the hat (or if she is, the tartan of her towel is of a clan quite unknown to me). B. She appears to be looking out to sea, but is in fact, on the top of a pair of kitchen steps in a photographer's rooms in Belsize Park.

The Costume

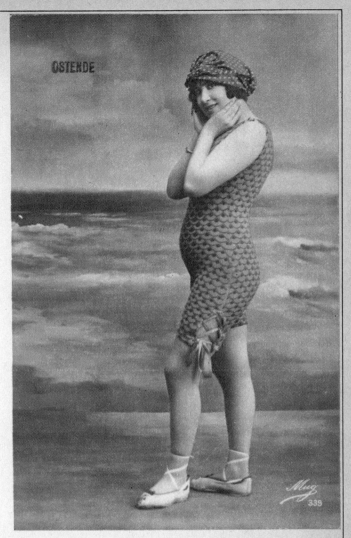

OSTENDE

What one wears on the beach is more important than ever nowadays, since Bathing has become one of Britain's major spectator sports. A thin, flat-chested girl scores no points in a bathing costume, as well we know. But, ladies, a word of advice. Choose carefully; do not appear to be *too* well-upholstered, otherwise your husband will start treating you like part of the furniture.

Another pitfall to be avoided. Due to the colouring of this costume, and the strategically placed rosebuds, the whole effect is one of complete nudity; and dressing as a deck-chair attendant does little to detract from the startling effect (in fact, upon reflection, I think it rather adds to it).

This costume would, in Frinton at least, get some very old-fashioned looks.

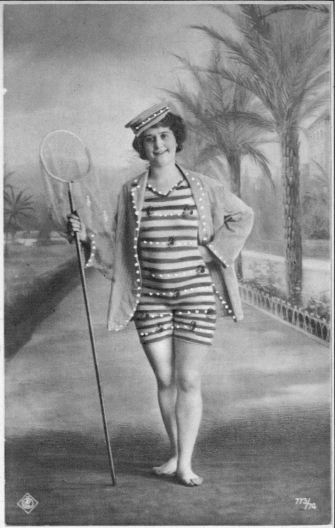

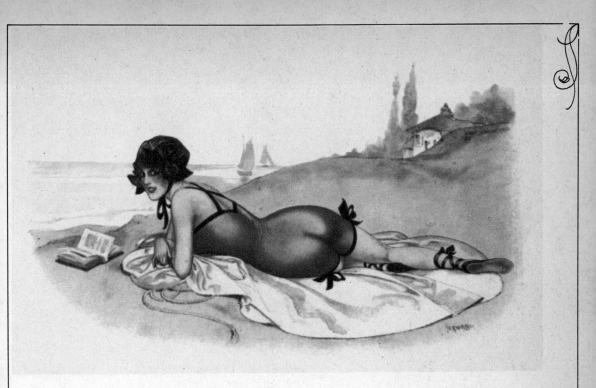

This rather novel appearance can be obtained
by applying to the bathing-costume a liberal
covering of red tile-polish, and buffing up with a
leather until an even shine is achieved.

Will glint in the sun and be seen for miles.

Here we see the ideal costume for the beach. It just shows what can be done with a few feet of linen, a few yards of muslin and a few miles of elastic.

None of them cost more than a pound—and as pretty as a picture.

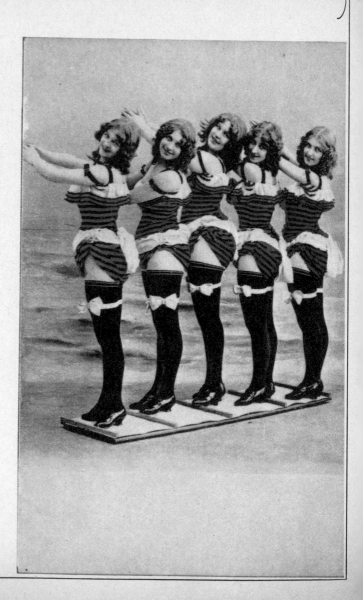

I fear, however, that the great majority will always persist in wearing costumes such as the ones which follow. A mixture of the Highly Impractical . . .

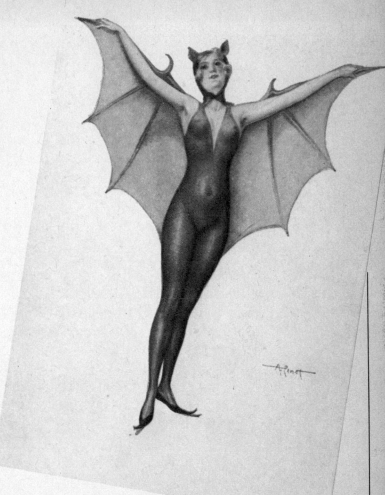

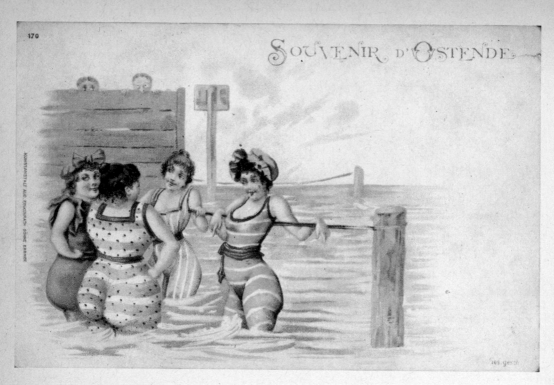

The Frankly Inadvisable...

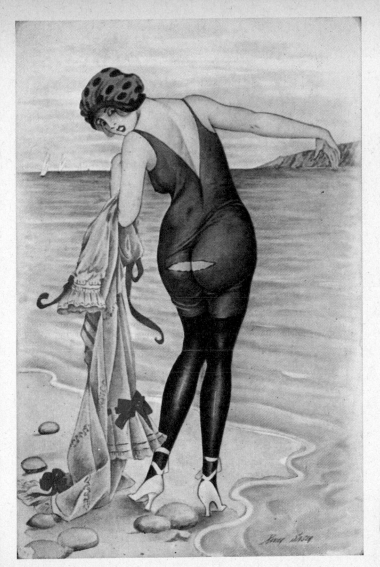

The Clearly
Undependable . . .

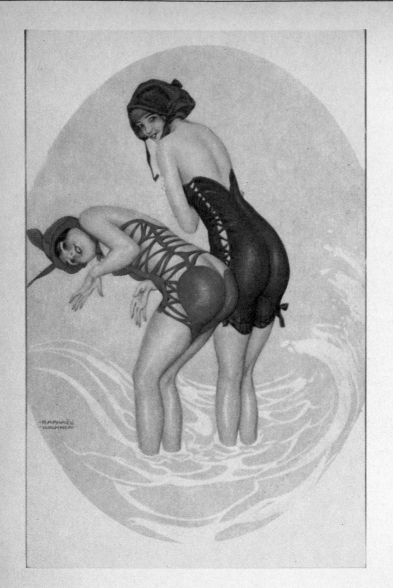

. . . and the Well-nigh
Impossible

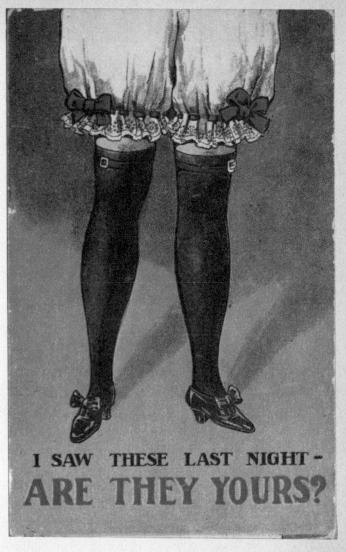

(For the answer, please turn
to page 96)

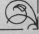

Sporting & Athletic Bathers

The wide, flat sea-shore is a natural choice for athletic pursuits, and the ozone is best taken in deep breaths, if the lungs are to be developed correctly (see left).

The hoop has lately replaced the bicycle as a means of getting from place to place, and the running is, of course, terribly healthy. However, be on your guard, would-be traveller. This girl ran many miles with her hoop, but had it stolen as she rested by the wayside, and, as a consequence, found herself stranded with no way of getting back home.

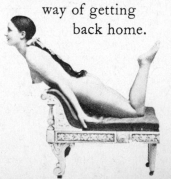

Ball-games, of course, are always popular, wherever they are played, and this remarkably agile girl is obviously enjoying what is normally considered a man's prerogative.

Although it must be said that she does appear to be straining her prowess to the utmost.

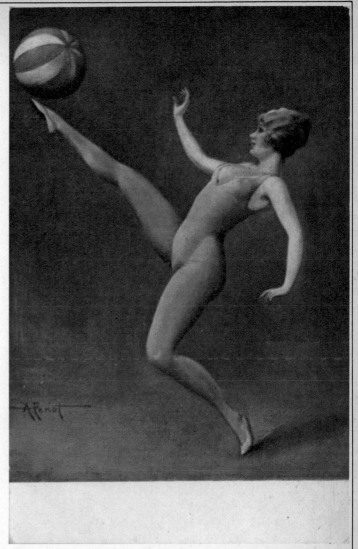

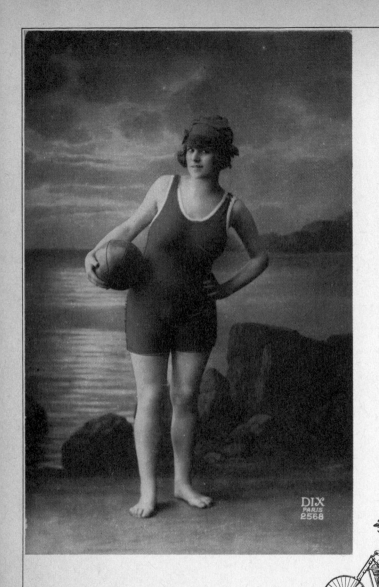

Women's football has, of recent years, become quite popular; and when played in this sort of bathing dress one can easily see why.

Mixed football is catching on, but mixed rugby, played in a similar costume was banned in Cheltenham after the first game. Apparently, out of a total of seven tries, four of them were successful.

Midnight Bathing

his, on the whole, is a pretty risky operation from start to finish.

In the first place, it is very tricky getting out of the house without being spotted by the locals, or receiving the full force of a policeman's lantern . . .

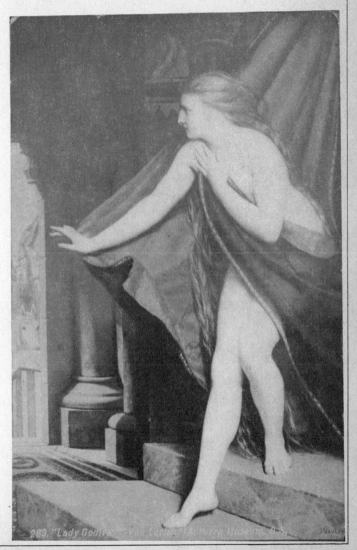

269 "Lady Godiva" Van Lerius—Antwerp Museum

Secondly, a pool at midnight can be quite unnerving when one is alone, with the wind howling, the trees creaking, and the possibility that, at any moment. some nocturnal tramp may suddenly appear from behind a tree, convinced that his dreams have come true . . .

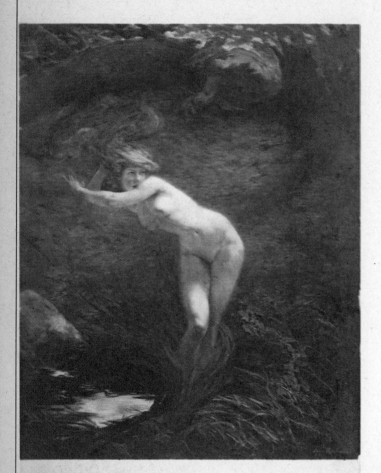

Salon de 1909. — *Le Chêne et le Roseau, par Jean Rachmiel*
3566 Dt. · *ND Phot.*

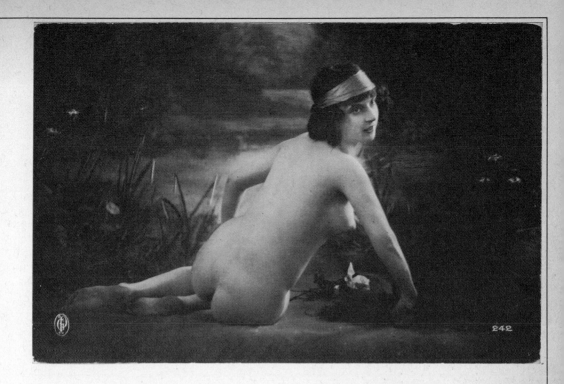

. . . and of course, by three o'clock in the morning, it gets decidedly cold.

People Who Would Bathe If There Were Any Water About

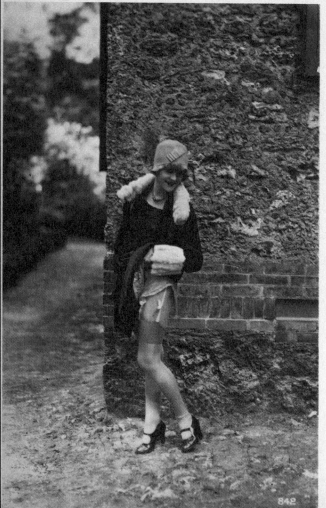

One meets this sort of girl mainly in the working-class districts, frequently in the suburbs of London, where opportunities seldom arise for a sea-side dip; and where many flats and houses do not possess a bathroom.

Signs to look for are a tendency to remove bits of clothing when in the presence of liquid (sometimes coffee—more usually gin or Beaujolais).

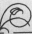

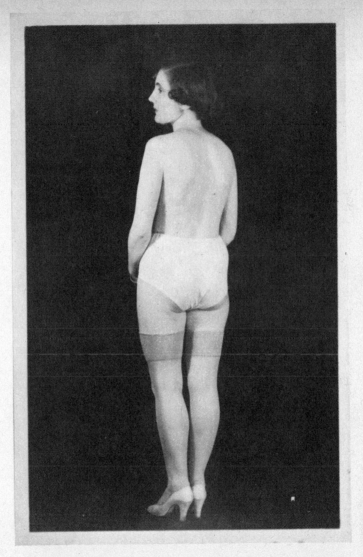

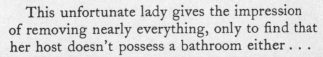

This unfortunate lady gives the impression
of removing nearly everything, only to find that
her host doesn't possess a bathroom either . . .

. . . and then, of course, there are people who do, even when there isn't.

Yachting & Punting

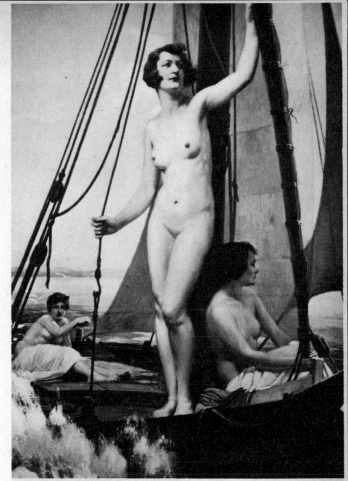

Salon de Paris — *A. FAUGERON* — VERS L'AZUR
TOWARDS THE AZURE — HACIA EL AZUL
6055 VERSO L'AZZURRO — NACH DEM AZURBLAU

The absence of costume here is, I am convinced, nothing more than an attempt by the Women's Liberation Front to campaign for equality on the high seas. The time-honoured phrase "Man overboard" would in these circumstances mean very little, when even the most short-sighted deck-hand could plainly see that it wasn't.

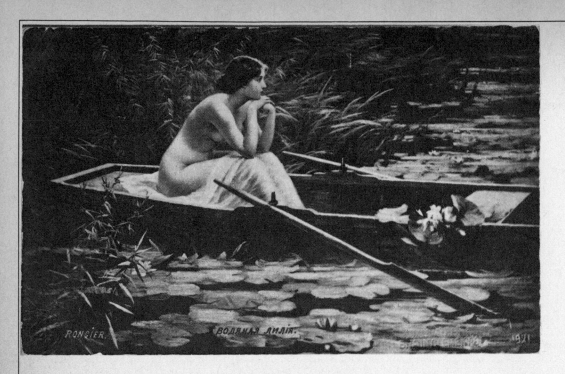

RONGIER. ВОДЯНАЯ ЛИЛІЯ. 1921

This is a much calmer way of spending a warm afternoon, lazily gliding under the willows that overhang the bank of the river.

The only annoyance one must guard against is the presence of thick weeds—two of which are seen approaching (right).

This girl was well-known as a riverside siren near Maidenhead some years ago. Being born near Aylesbury, she became known as "the Aylesbury duck". She pestered a particular millionaire who lived along that stretch of river so much that he eventually grabbed a shot-gun and, as he put it "got in a little duck-shooting". The first barrel missed, but the second got her in the bulwarks, and she sank immediately.

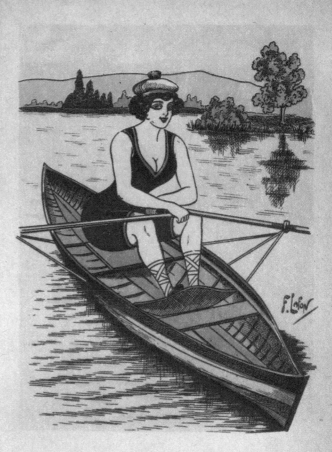

LE CANOTAGE

161

Graceful Bathers

The epitome of maidenly grace– the Hon. Priscilla Davenport-Hardy-Bloemfontein of Cirencester. The youngest daughter of an old family renowned for its dedication to bathing as an improver of carriage, deportment and health.

Her elder sister (below) was said to spend more time *in* hot water than out of it.

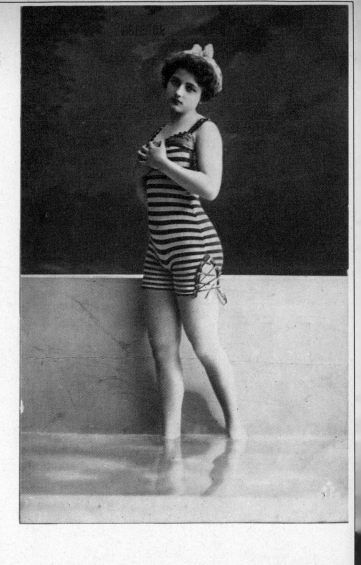

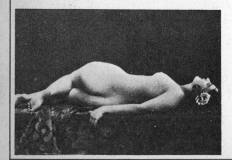

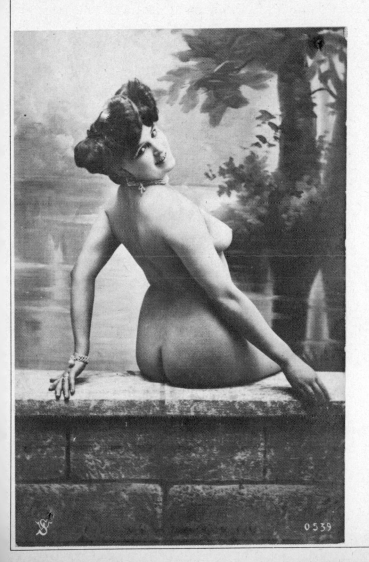

Her mother, the Marchioness, would invite the nation's photographers to her extensive country seat once a year, to witness and record her annual plunge into the ornamental lake. This tasteful picture was taken by "The Sphere". Unfortunately a mere two minutes later she caught one of her bathing pumps on a nail, and hung upside-down by one leg providing the more sensational newspapers with a full centre-spread for Sunday's breakfast-table.

Fearless Bathers

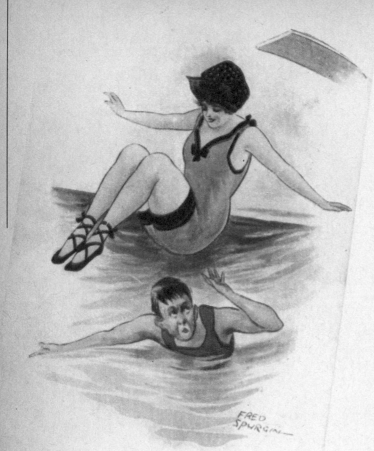

SORRY COULDN'T LET YOU KNOW
I WAS COMING DOWN!

Not for her the cautious dipping of one toe into the foam. It's "Up guards, and at 'em." Or in this case, down guards, and on 'em.

Do you think she has had a practice on the bed at home?

Another exponent of the depth-charge method. The water looks so green and uninviting that I am reminded, somewhat indistinctly, of the delightful poem (and here I misquote),

"The temperature of water is, to me, a source of wonderment;
It feels so warm upon the hand, so cold upon the fundament."

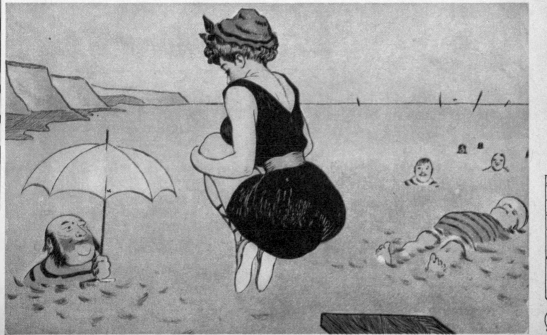

Communal Bathing

This lively gathering of enthusiastic bathers says much for the charming practice of bathing in a group, and somehow captures the spirit of the Nudists' National Anthem:

"All in together,
In the altogether
 Never mind the weather
That we're all together in."

This particular group is a coach-party of typists from the Thermal Establishment in Monte Carlo. (The coach-driver has gone for the towels.)

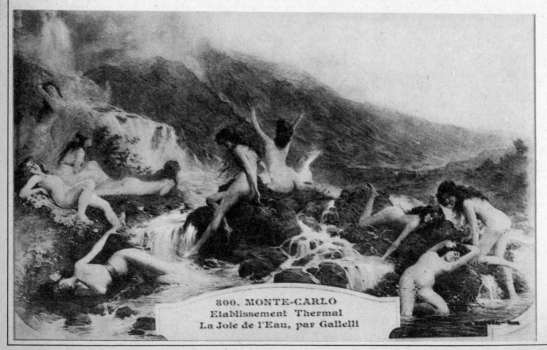

800. MONTE-CARLO
Etablissement Thermal
La Joie de l'Eau, par Gallelli

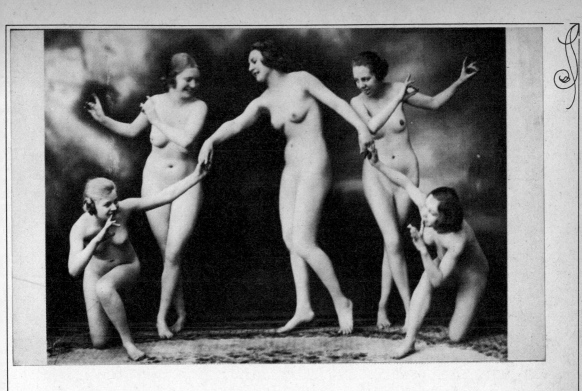

The Rickmansworth Young Gentlewomen's Guild (depicted here) meet every Thursday for community bathing and slimming exercises. "We're all trying hard to lose weight in different places. I've hardly got any top left," says Peggy (bottom right). "I've got to get my bottom right," says Eva (top right). "I've got my top right, but there's still my bottom left." Janet (bottom left) agrees. "I've got my bottom right, but I've still too much top left." Mary (top left) giggles, "You're right. I've certainly got too much top and bottom left all right." Diana (centre) refused to comment.

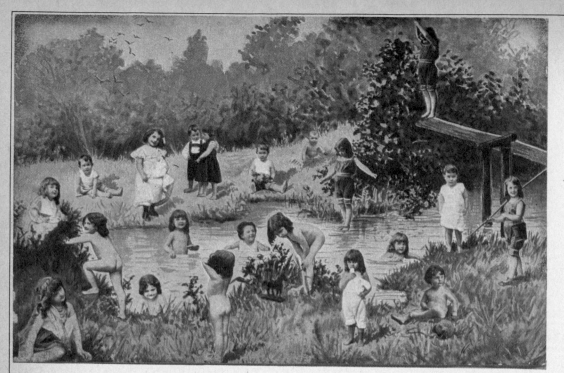

Juvenile Bathing

"What an idyllic scene" I hear you say. "How lucky the photographer was, to be there to perpetuate it." Alas, I am afraid that such a moment never even existed. The children were all photographed separately, then cut out and stuck on to a river background.

Which seems a shame, until you think of all the pushing, pinching, punching, biting, biffing, cursing and crying it prevented.

Underwater Bathing

Portrush.

VIEW & PORTRAIT CO.

I include here, for what it is worth, a photograph of Underwater Bathing taken from *above* the surface. (It is actually worth about 35p)

Formation Bathing

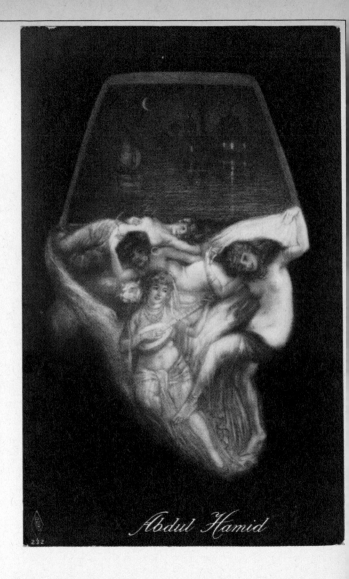

Abdul Hamid

Sometimes known as "Tableaux Vivants", this enchanting entertainment consists of bathing girls forming themselves into an apparently haphazard group which, when viewed from afar, becomes a portrait of a famous leader or statesman. (Get a friend to hold this book a long way away —but mind he doesn't run off with it.)

Rudeness on the Beach

Now look here. There is no need for this sort of thing. Before we know where we are, someone will get annoyed, the gentlemen will start fighting, and there will be tears before bedtime, mark my words.

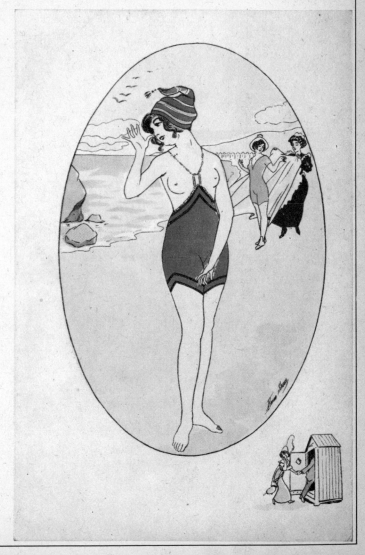

Compulsory or Enforced Bathing

In the middle ages, when a girl refused to wash, this was her fate. Pushed in fully clothed, she was forced to undress completely in order to stay afloat. This served a double purpose, shaming the girl into cleanliness and creating a day out for all the family. As soon as she had removed her clothes, a trunkful of clean, dry ones was flung into the water, for her to change into.

How to Swim

A page for the enthusiast

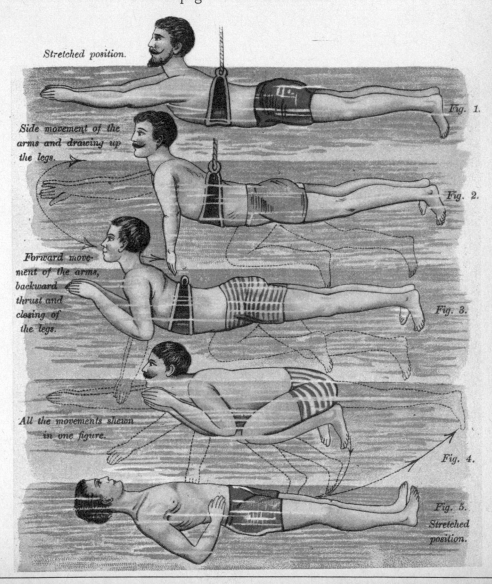

Stretched position.

Fig. 1.

Side movement of the arms and drawing up the legs.

Fig. 2.

Forward movement of the arms, backward thrust and closing of the legs.

Fig. 3.

All the movements shewn in one figure.

Fig. 4.

Fig. 5. Stretched position.

Appendix 1

The History of Bathing

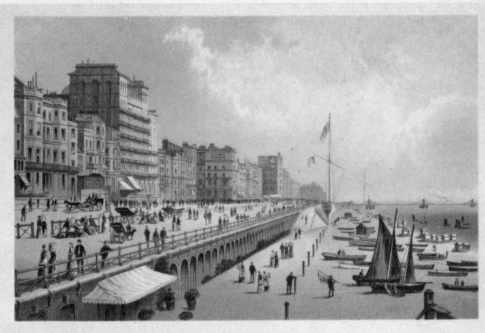

KING'S ROAD — BRIGHTON

Brighton—where it all started
(and where a lot of it still goes on).

I here append a short history of bathing, which will probably
turn out to be fairly boring, so I shall quite understand
if you don't read it. The reason I include it is simply that
a short history of the subject is always expected in a work of
this magnitude (or lassitude). However, please don't expect the
facts to be at all accurate or precise.

In 1788 (or it may have been 1814), the village of
Brighthelmstone nestled quietly among the rolling downs of
Surrey, or Sussex. At this time, the sea was regarded as a
fearsome element, and hardly anyone except sailors ventured

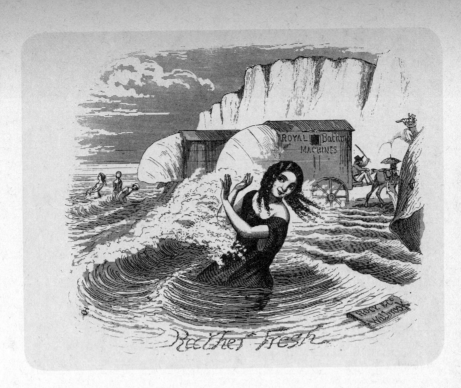

Rather Fresh

on it, let alone in it. However, the Prince Regent or George
the III or IV as he was known, was ordered there for his health,
and promptly took the whole of the court with him (except
Mr. Disraeli, of course, who was only a boy of three at the
time—that I *do* know). Within a few months, or years, the
delights of sea-bathing were beginning to spread; and so,
unfortunately, was the Prince Regent. He died between 1821
and 1836, of "an overdose of life"—but not before he had
bequeathed to the nation the charms of his beloved Brighton
(the name was shortened to get it on the postcards).

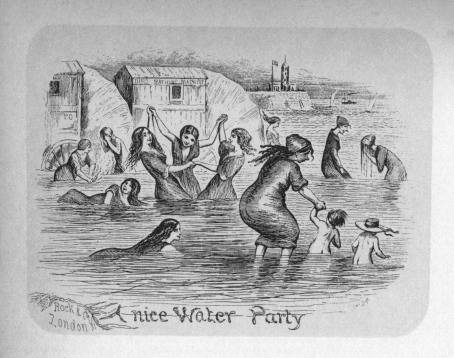

A nice Water Party

It became a family affair. Large huts on wheels, called "Bathing Machines" were trundled into the water by horses, so that ladies could step from them straight into the waves "at a reasonably decent distance from the shore, away from the gaze of common sightseers and rude fishermen."

This of course, merely meant that the rude fishermen did a roaring trade in "trips around the lighthouse" and the sale of binoculars went up by 85% (*vide* "The Times", Sep. 15th, 1852, page 3, col. 4).

The binoculars, as it turned out, were still cheap at the price; for the simple reason that those same ladies who pretended to shun the gaze of the gentlemen on the shore began to fall over themselves in their efforts to outdo each other in their choice of bathing costume (as the following pages show).

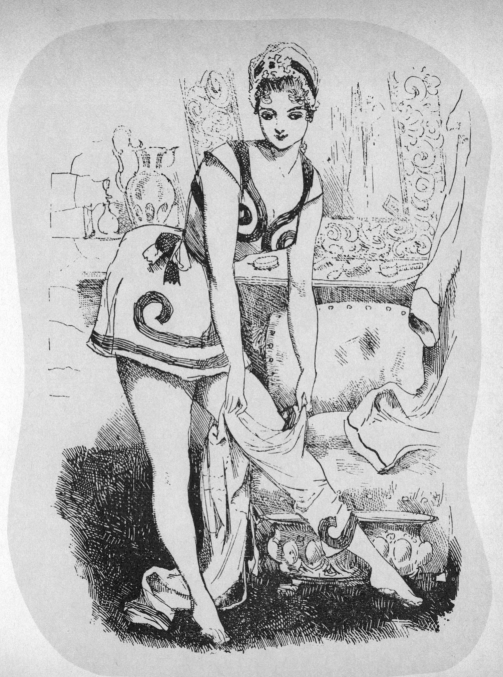

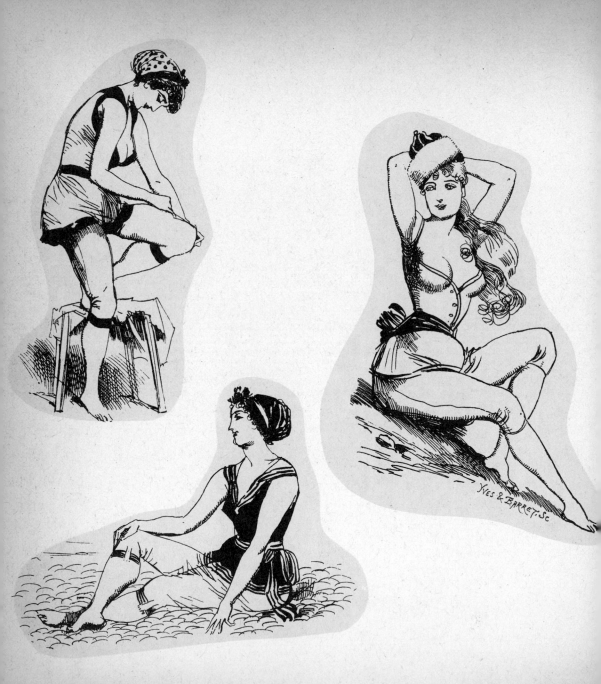

YVES & BARRET · Sc.

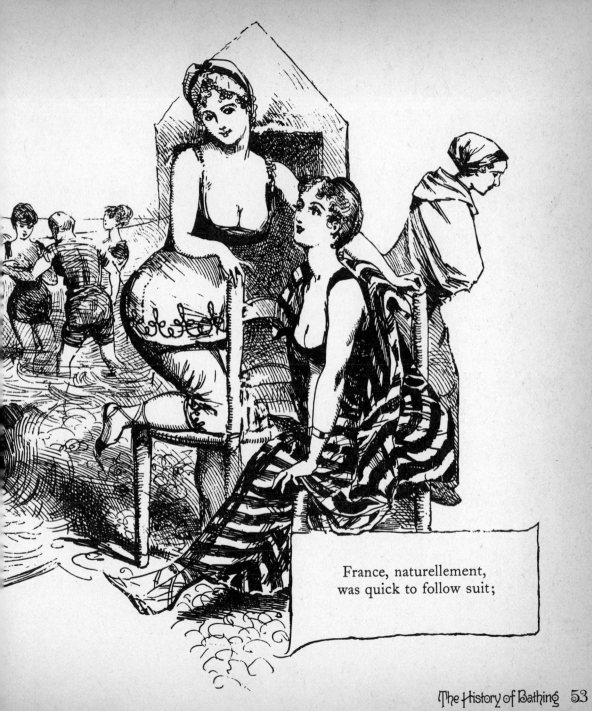

France, naturellement,
was quick to follow suit;

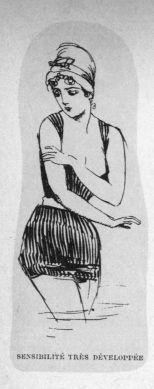

SENSIBILITÉ TRÈS DÉVELOPPÉE

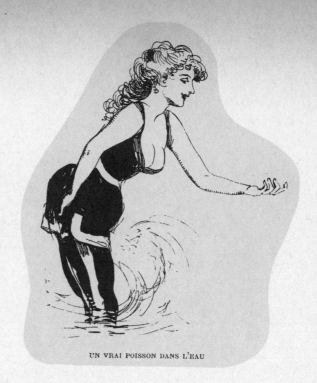

UN VRAI POISSON DANS L'EAU

and by 1884, when these drawings were published, they had
of course overtaken us in daring and decolletage (see above).

I suppose it to be only natural that if girls such as the dainty
morsel on the right were being described as "a veritable fish in
the water" (my own translation), then we mustn't complain if
the fish . . .

. . . start behaving like people.

But enough of history.
Let us start wading through the INDOOR
BATHING SECTION.

SECTION TWO
INDOOR BATHING

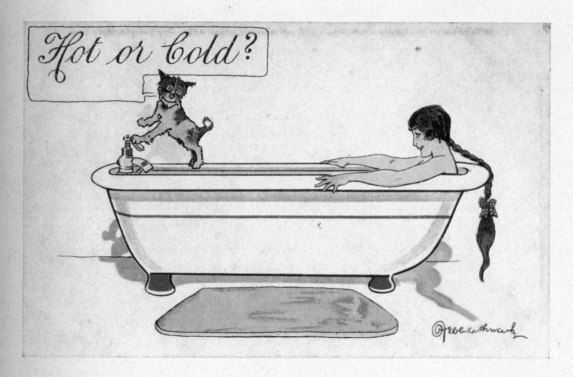

This form of bathing is not at all like the other sort; one is boisterous and extrovert; the other, calm and relaxing (at least, it is in my road).

The other main difference, of course, is that indoor bathing is usually performed without clothes on. For this reason, the following section will probably disappoint the more fashion-conscious reader.

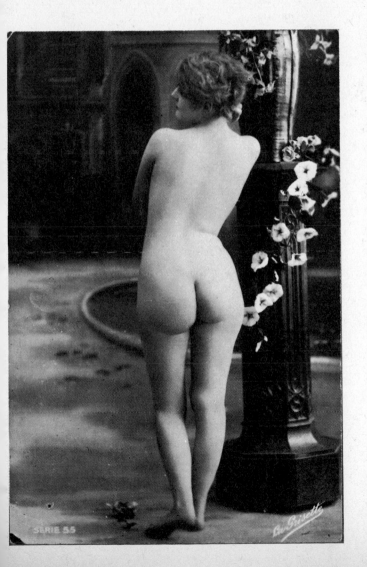

Incidentally, about the pronunciation of this word "Bathing". When referring to the outdoor variety, the "A" is made to rhyme with the word "FACE". With the indoor kind, however, the "A" is sounded as in the word "FARCE". (I have always felt that this point should be cleared up, as many people find it confusing —hence the expression "Getting it Farce about Face".)

One thing a woman *does* wear in the bathroom of course—perfume. (Witness the contents of her dainty handbag.)

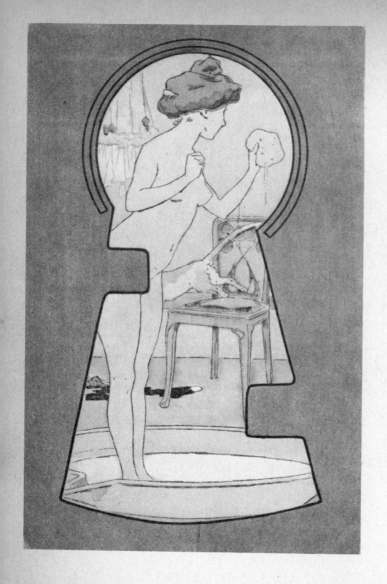

HOTEL LIFE

Porter (peering through
keyhole), "I thought so.
She's got a furry
animal in there. The
manager wouldn't
half like to see that".
(And so he did.)

MAYFAIR LIFE

Parlourmaid (thinks),
"Lucky the mistress
knows a fireman, or
she'd never be able to
to get it filled".

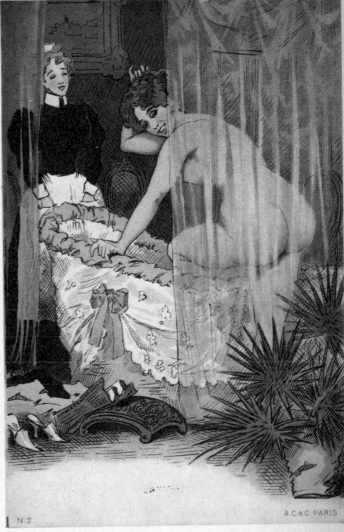

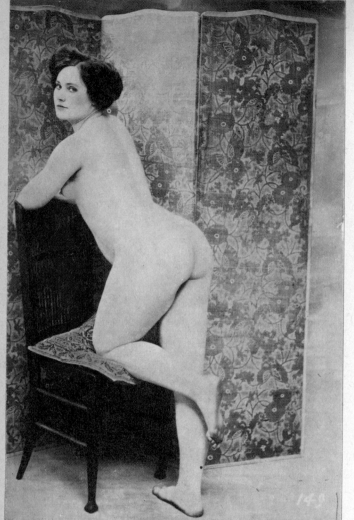

LIFE IN "DIGS"

Waiting for the Bathroom. "Are you goin' to be long, Mr. Phipps? Only I gotter get to a dress rehearsal."

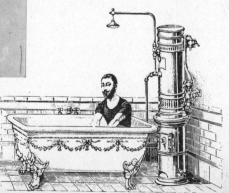

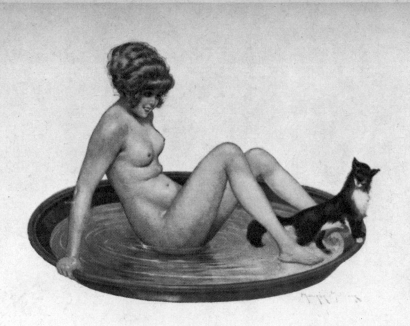

Partial or Economy Bathing

Purely and simply, of course, to save hot water. I must confess that this form of economy seems to be over-stringent, in these enlightened days, when nearly every girl possesses a back-boiler.

In more backward countries it is, I suppose, only to be expected (see Spanish leg-bath, right).

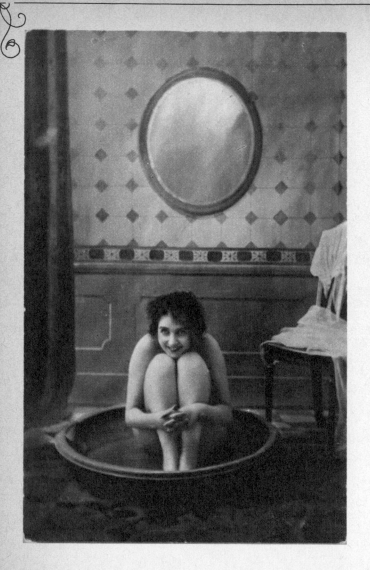

This bath appears to have no water in it at all. I can only presume the young lady has removed a couple of roof-tiles and is waiting for it to rain.

(Below: Mexican Elbow-bath—Pat. Pending)

Please note: page 63 is to be found on page 97.

D.I.T.W.O.

. . . or to give it its full title—Dressing In The Wrong Order.

A common fault with Bathing Beauties, but nevertheless an enchanting one; and perfectly harmless, providing there is only one person getting dressed at once. (Some years ago I saw a large red-faced man in a hotel lounge, trying to pretend he hadn't got women's shoes on.)

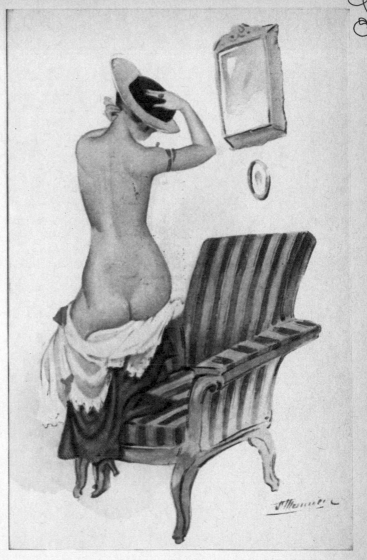

Towel-conscious Bathers

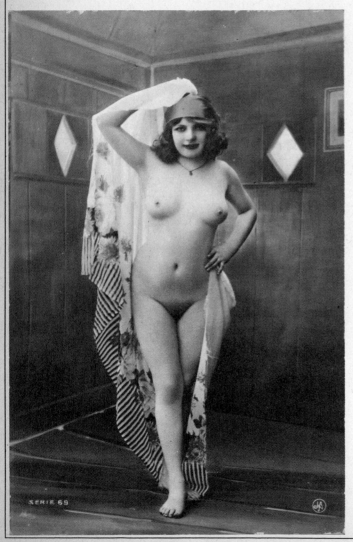

SERIE 69

This sort of impulse is usually revealed when the subject is surprised suddenly — i.e. coming face to face with an intruder in her bathing-hut (as in our picture, left). She will invariably try to cover up what she considers to be her weakest point—in this case her hat.

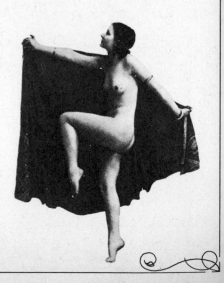

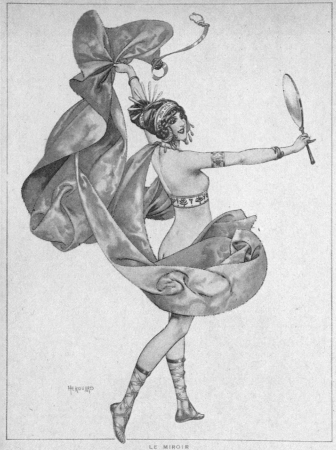

LA VIE PARISIENNE Dessin de C. Hérouard.

LES ARMES DE VÉNUS

HÉROUARD

LE MIROIR
Le seul conseiller dont les réflexions ne lassent jamais les femmes

Some girls, on the other hand try to compensate by being over-flamboyant with their towels, and only succeed in drawing attention to themselves.

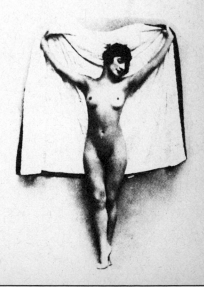

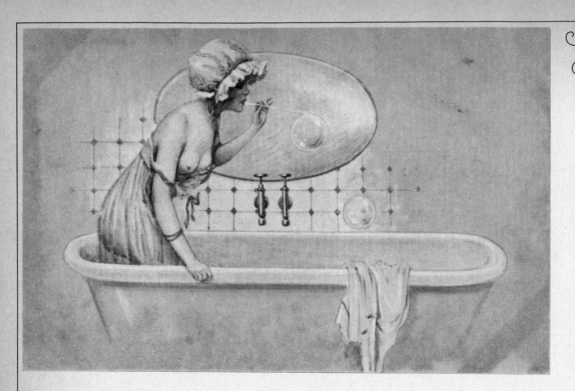

Hobbies in the Bath

Best confined to suitably wet occupations, such as rubber-duck floating or a submarine hunt; or, charmingly illustrated here, the art of Bubble-blowing. (This girl is obviously so engrossed with her two beauties that she stepped into the bath still wearing her chemise.)

More boisterous games, such as cricket, played with a loofah and a bar of soap, have been tried and found wanting—mainly because no one wants to be wicket-keeper.

Show-offs

Frankly, my un-favourite type of Bathing Beauty. A girl's pride in her figure may be all very fine and large (and this one certainly is) but this sort over-flaunts it to a nauseating degree.

Concerned as she is with blowing her own trumpet, it goes without saying that in her apartment is usually to be found a gramophone with a very large horn.

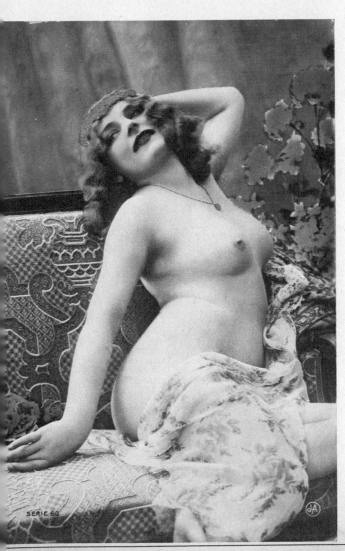

Nervous Bathers

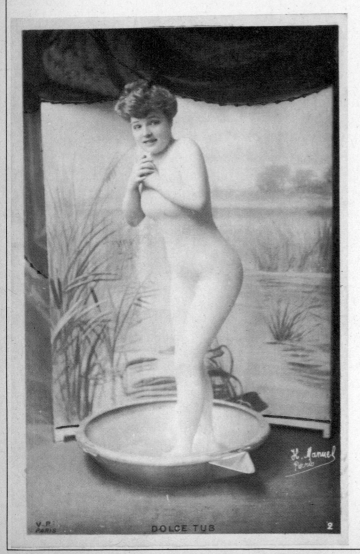

DOLCE TUB

Here we see a French photo of a British girl (actually a friend of my Aunt Norah) whose name, spelled wrongly on the card, is in fact Dulcie Tubb.

A splendid girl in many ways, Dulcie is so terrified of burglars that she always wears a complete leotard, or body-stocking when she takes a bath, and spends the entire time wondering whether she left the window open.

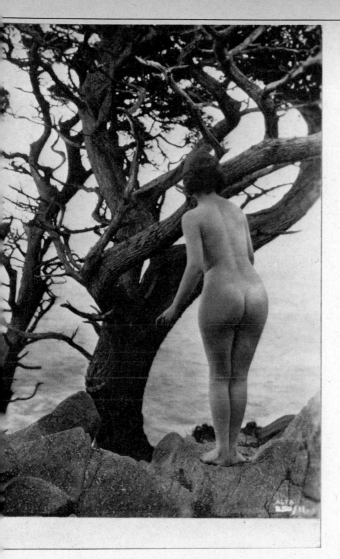

This girl is nervously looking out to see. Not out to sea, you understand, but out to see if the coast is clear.

Fortunately for us, she failed to notice the photographer who came up behind her with his little Brownie.

Bathing in Far-off Lands

"Here with a loaf of bread beneath the bough,
a bath at nine, a hookah pipe, and thou"

Omar Khayyam

Pictured right: a hookah extension, for smoking in
the bath (By courtesy of the British Museum).

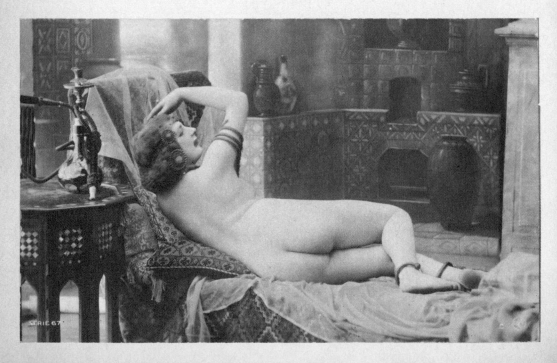

SERIE 67

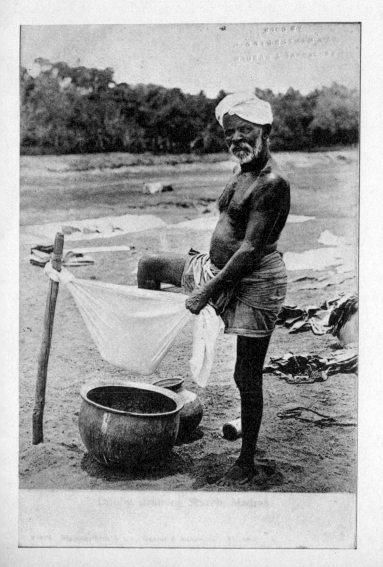

In countries where water is short, this was until recently the only method of bathing. However, most villages now possess a communal portable wash-stand (below) which affords the agile native the hitherto unknown luxury of washing both feet at once.

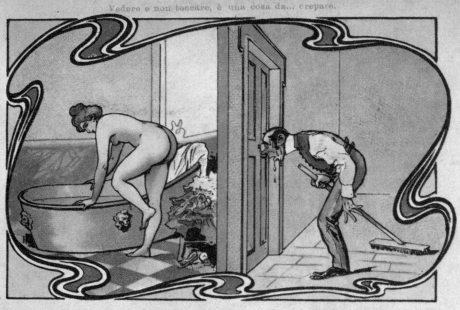

Vedere e non toccare, è una cosa da... crepare.

Voir et ne pas toucher, c'est une chose à... crever.　　Sehen und nicht greifen ist Zum verzweifln.

Careless Bathing

A time-honoured situation, you might think. The careless young lady has neglected to fill the keyhole with soap, as is the usual practice; but the amazing thing to me is that neither the foolish girl nor the dull-witted servant has noticed that half the wall of the bathroom is missing.

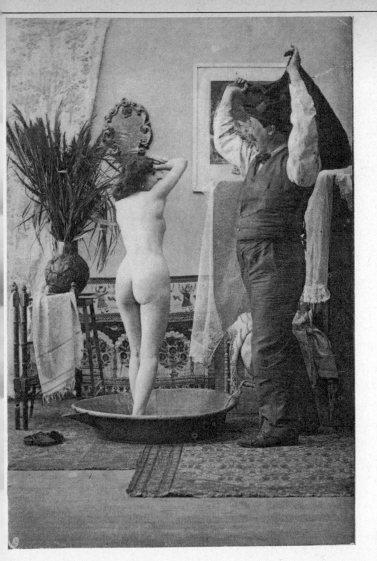

The Unlocked Door
(Episode One)

"Morning, lady! Coalman. Where do you want it?"

"Good heavens—have you no scruples?"

"No miss—just a hundredweight of nutty slack."

(to be continued)

The Unlocked Door
 (*Episode Two*)

"Nice little place
you've got here, lady.
Mind if I look round?"
(A smile)

"You're looking
pretty round yourself,
miss, if I may make so
bold."

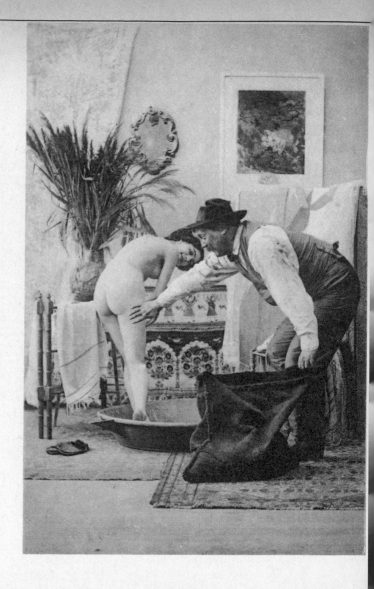

(to be continued)

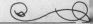

The Unlocked Door
(*Episode Three*)

Obviously a satisfactory conclusion. The young lady appears to have accepted the coalman's delivery, and he, being of a domesticated nature, is now in the process of tidying up the tell-tale finger-marks. Let's hope he had a patient horse.

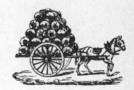

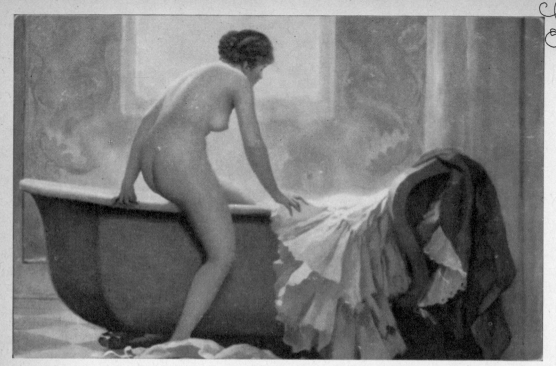

Honest-to-goodness Bathing*

Finally, I end the "Indoor Bathing" section
with those ordinary, healthy, wholesome girls who
simply get into a bath . . .

*(Not to be confused with "*Indeed-to-goodness*"
Bathing—see *Welsh Bathing*)

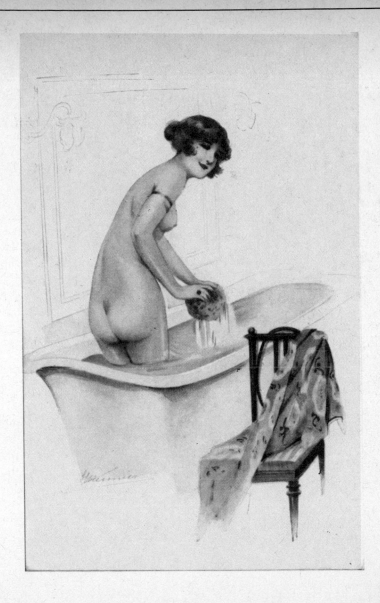

... Grab a sponge and some soap ...

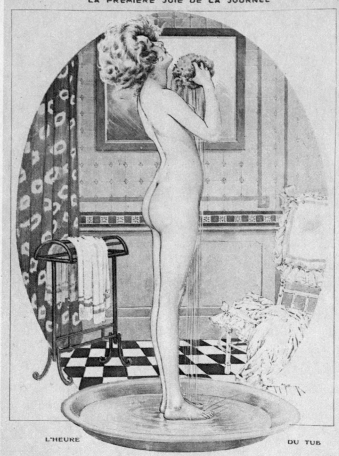

Dessin de Maurice Millière

LA PREMIÈRE JOIE DE LA JOURNÉE

L'HEURE DU TUB

. . . Wash away all the cobwebs . . .

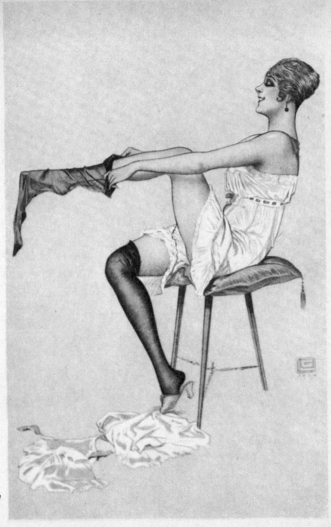

... Get out, dry themselves, get dressed, and go down to the bridge club and thrash the other girls at tennis!

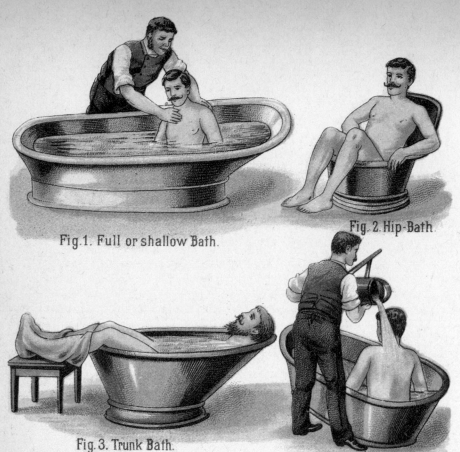

Fig.1. Full or shallow Bath.

Fig. 2. Hip-Bath.

Fig. 3. Trunk Bath.

Fig. 4. Back affusion in Bath.

Appendix 11 - Medical Bathing

This set of drawings, discovered in an old copy of "The Knife-grinders' Gazette" some years ago, would indicate that much of this remedial treatment (usually as a cure for lumbago, gout, or mere disinterestedness) seems to have been carried out by gardeners (witness the green watering-can).

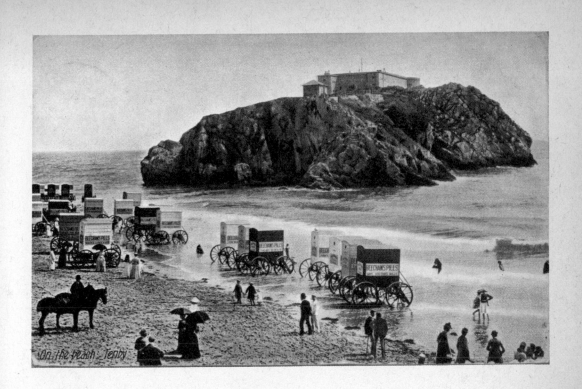

The annual Bathing-Machine race, organised by Beecham's Pills at Tenby, in Wales. The winner received, as a prize, a year's supply of Beecham's Pills for himself and a friend, and a copy of the recently published book "How to Live Forever" by the late Professor Ballard.

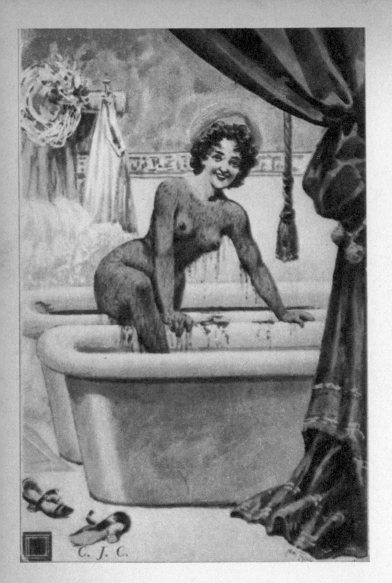

C. J. C.

The Mud-bath has always been considered efficacious for the cleansing of the skin, and of recent years certain hotels have been specially equipped and staffed to provide this service.

An air of jollity and abandonment often pervades these bathing establishments, and the boisterous behaviour of the wealthy guests, (usually after dinner) has led to expressions such as "mud-slinging", "where there's muck there's money" and "I'm off for a dirty week-end".

Fig. I Home-improvised Eyebath

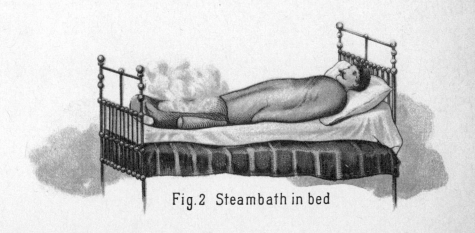

Fig. 2 Steambath in bed

Comic Bathing

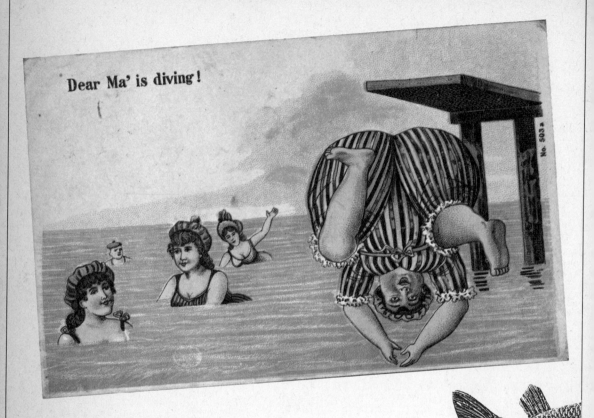

Dear Ma' is diving!

No. 503a

We now come to the two final sections; first, Comic Bathing. Due to the somewhat clinging nature of the wool or cotton bathing-suits when wet (revealing in more detail the shape of that which nature has given us to sit on), it is only to be expected that the comic artist of the

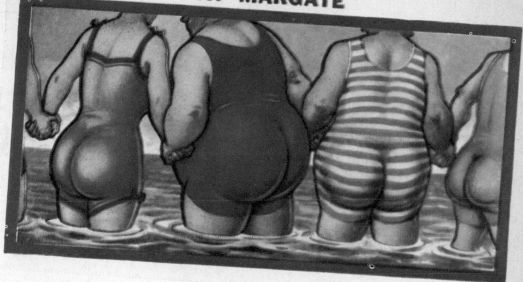

THIS 'S HOW YOU GET ROSY CHEEKS AT THE SEASIDE
AT MARGATE

day appeared to concentrate his ribaldry upon the posterior eccentricities of the (usually) female form, and the increased dangers it was exposed to . . .

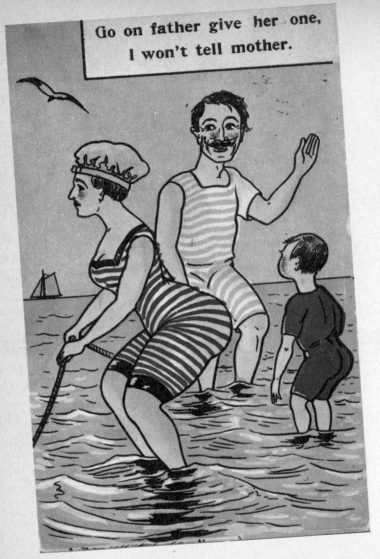

... namely, an attack from the rear, perpetrated
by some complete stranger ...

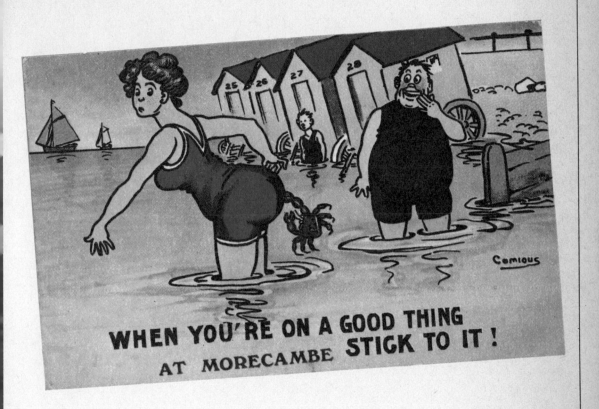

... whether it be humanoid or crustacean.

Interlude - Your Questions Answered

The Mermaid

These creatures do *not* exist.
(But if they did, they would be extremely expensive per lb.)
Below, the Manatee, or Sea-Cow.

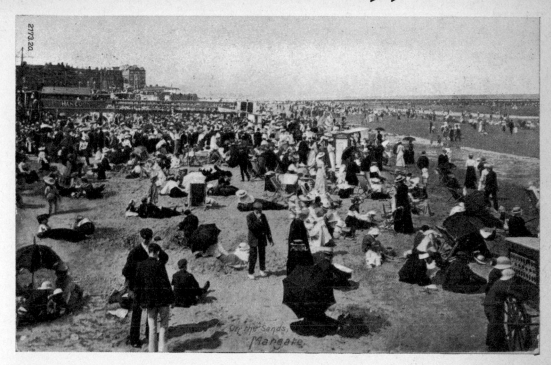

On the Sands, Margate.

Real People Bathing

As we near the end of this volume, let us away with all pretence and artifice, and look, at last, not at "models", but at REAL people. Let us find the ordinary face in the crowd.

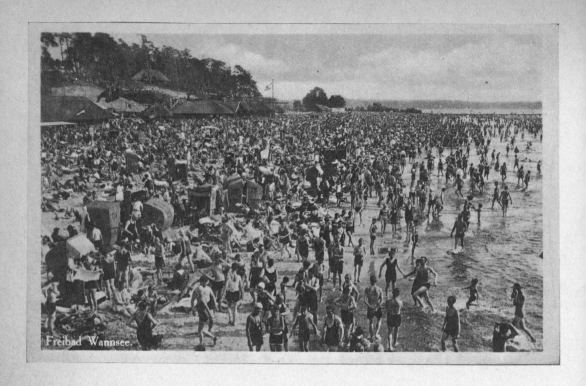

Freibad Wannsee.

The only trouble being, it is usually such a big crowd, you
can't find anybody . . .

91 Real People Bathing

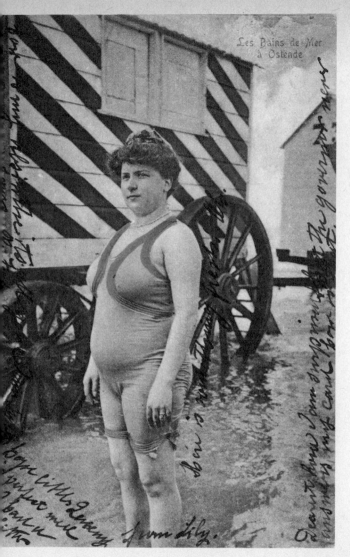

Les Bains de Mer
à Ostende

...although some stand
out more than others.

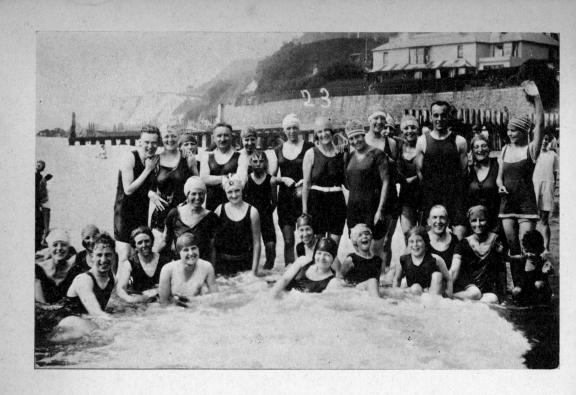

But I'm happy to say that this photographer has managed
to find a group of holiday-makers who aren't camera-shy.
Their figures may not be perfect, but their faces are happy.
Those of them who have a copy of this snapshot will remember
the occasion all their lives; and I
hope that this little book has brought
back a few memories for you too.

Special Appendix

"THEY TOOK OFF THEIR HELMS AND KISSED EACH OTHER."

For gentlemen who don't like Bathing Beauties

Addenda

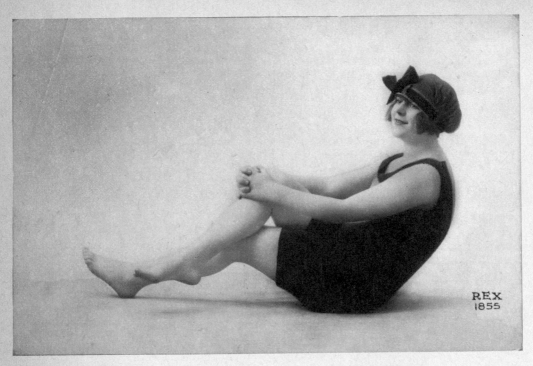

Bathers that defy description.

(N.B. Do not miss the end—on the next page)

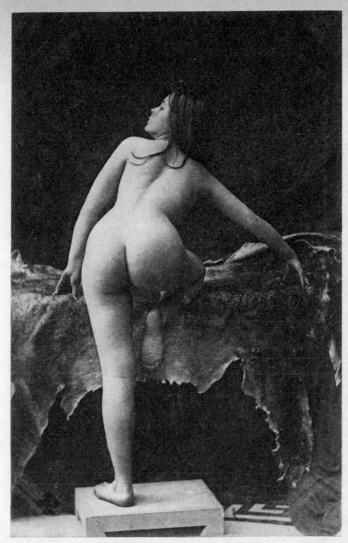

The End

P.S. (The answer to the question on page 21)
"No—I don't wear any."

(SEE NEXT PAGE)

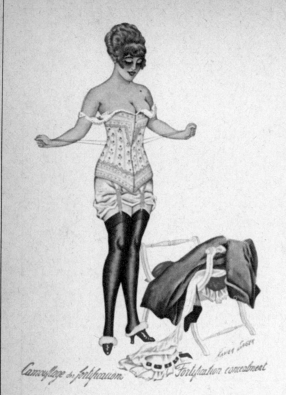
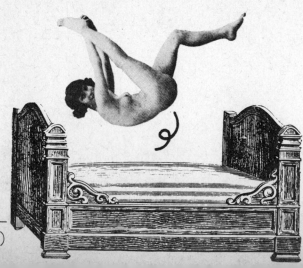